DISARMING THE PRAIRIE

CREATING THE
NORTH AMERICAN
LANDSCAPE

Gregory Conniff

Bonnie Loyd

Edward K. Muller

David Schuyler

Consulting Editors

George F. Thompson

Series Founder & Director

Published in cooperation
with the Center
for American Places,
Harrisonburg, Virginia

with an introductory essay by Tony Hiss

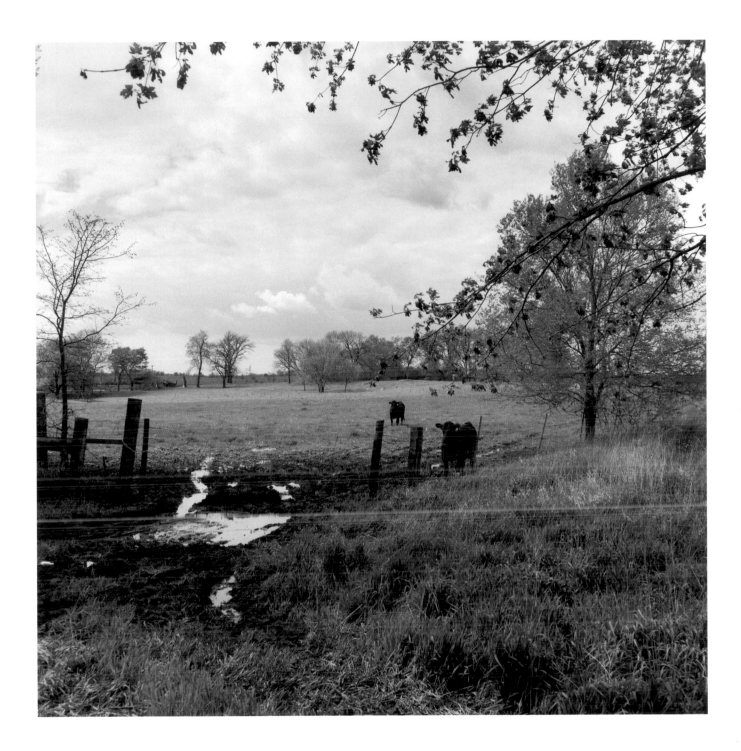

DISARMING THE PRAIRIE Terry Evans

The Johns Hopkins

University Press

Baltimore & London

This book was brought to
publication with the generous
assistance of Openlands
Project, of Chicago, Illinois,
Gerald W. Adelmann,
executive director.

The Johns Hopkins
University Press
2715 North Charles Street
Baltimore, Maryland
21218-4363
The Johns Hopkins Press Ltd.,
London
www.press.jhu.edu

Library of Congress
Cataloging-in-Publication Data
will be found at the end
of this book.
A catalog record for this book
is available from
the British Library.

ISBN 0-8018-5936-0
ISBN 0-8018-5935-2 (pbk.)

CONTENTS

Frontispiece: Cattle grazing, Joliet Arsenal, east side, May 1995.

To my parents, Norman and Dale Hoyt, who taught me the art of photography and the art of exploration.

FROM WHERE I STOOD, at the Joliet Arsenal, the cow pies, old winter straw grass, and bare, open slope of the heavily grazed cow pasture looked oddly like an abandoned battlefield as photographed by English photographer Roger Fenton in 1865. The photograph, taken shortly after a Crimean War battle, shows bare sloping ground and a path faintly etched, a hundred cannonballs or more scattered on the ground, and not a person, living or dead, in sight. The military presence on this arsenal landscape was immense, too, with ammunition storage bunkers, 200 miles of narrow-gauge railroad tracks, decaying dynamite factories. The workers were long gone. On this midwestern landscape, I was surrounded by the bare bones of preparation for three wars: World War II, the Korean War, and the Vietnam War. I stood there first in February 1995.

Then spring came. When I returned, green was beginning to cover the stark gray outlines of abandonment. Lime green leaves on burr oaks, yellow haze on sugar maples, Virginia bluebells unfolding vivid color brought the land alive again. Nature had reengaged this military landscape.

The mysteries of the abandoned human stories combined with nature's changes drew me repeatedly to the former arsenal. I wanted to explore this land extensively with my camera. With the permission and assistance of the U.S. Forest Service and Openlands Project, I began to photograph there and continued until fall of 1997. The photographs show the land prior to its restoration, which is happening now.

To understand the space of the 25,000 acres of former arsenal land, I needed to see it from above. From the yellow Piper Cub plane flown by pilot Steve Keibler, at an altitude of about 700 feet, I photographed relationships of places on the ground. I saw that Prairie

PREFACE: Disarming the Prairie

Creek runs beside the manufacturing area, down through Starr Grove, and I saw a cemetery through a small clearing in the trees. The Drummond Prairie, with its long dropseed grass clumped beside railroad tracks, sits in a far corner outside the arsenal's perimeter chain-link fence and beside power lines next to a marsh. When flying, I saw one place after another revealed quickly, and a map of the area took shape in my mind's eye.

My affection for the land grew as I gradually became acquainted with it. I investigated ruins of arsenal buildings, farms, the Plenemuk prehistoric burial mound, and artifacts of glass, wood, and tin in the ruined house foundations in Hoff Woods. Each time I made a new discovery, I felt the excitement of an archeologist discovering an ancient mystery filled with promise, but I also felt sadness for the land. Every time I was there, these contradictory feelings occurred. Was I feeling nostalgia?

The archaic meaning of the word *nostalgia* is "a severe melancholia caused by protracted absence from home or native place." It seemed to me that the land was longing for its former self. Or was it me longing for the return of the land to itself?

This is a book of hope, about a place on the verge of restoration, a place that has been used solely for human purposes now given back to nature with human care. The Joliet Arsenal is becoming the Midewin National Tallgrass Prairie Park. This is a book mainly about the stories of human use of this land up until now. We used to be asking the question, "How can this land serve us?" Now we have turned the question around and are asking, "How can we serve this land?" There will be new human stories mixed with the grasses, but the prairie's own story of grass will speak strongly again.

HEROISM AND ITS AFTERMATH This is a book whose images explore one of twentieth-century America's most problematic and least discussed legacies—the militarization of our landscape. In 1937, in the quiet days before the beginning of World War II, military agencies had the use of about 3 million acres of American soil; twenty years later, at the height of the Cold War, that figure had grown to 30 million acres, putting the country in the grip of something never seen before—military sprawl.*

In the more than thirty-five years since President Eisenhower pointed with concern to the economic power of the country's post–World War II military-industrial complex, very little attention has been paid to the actual physical expansion of American military space. Landscape historians are still accustomed to thinking of agriculture, industry, urbanization, and transportation as the four principal human forces that alter the face of the earth. Large-scale post–World War II road maps, which proudly display national parks, national forests, and the new interstate highways, tend to omit the equally new military reservations. Many recent armed forces acquisitions, particularly in the Southwest, displaced few existing communities and thus didn't trigger the classic "land-use conflicts" that torment areas where a new human purpose is elbowing aside an established one.

These military installations, in remote areas, occupied land that had always been publicly owned. The change, invisible to outsiders, was in the nature of the land's public stewardship; after a long series of what were officially called military "withdrawals," a great

*Recent post–Cold War base closings have diminished this domain; it now totals close to 20 million acres, which is twice the size of the tristate New York City metropolitan area and about as large as Austria. It's also just over 1 percent of the "Lower 48."

TURNING BULLETS INTO BIRDS Tony Hiss

deal of territory passed out of civilian control. More obvious to people all over the country was the militarization of the atmosphere—more than half of America's airspace, meaning the skies above 960 million acres of land, had by 1986 been reserved for military use. Many people now carry with them unforgettable, frightening memories of moments when the quiet over sanctuaries such as Sequoia–Kings Canyon National Park or the Everglades is exploded by sonic-booming, treetop-hugging fighter jet training flights that swoop down to within 100 feet of the ground.

PHOTOGRAPHY STEPS IN Like the nineteenth-century poets and novelists who first helped people focus on the consequences of massive urbanization and industrialization, several twentieth-century photographers are among the first concerned citizens calling attention to the impacts of military sprawl. In the early 1990s, two masterful American landscape photographers, Richard Misrach (in his book *Bravo 20: The Bombing of the American West*) and Peter Goin (in *Nuclear Landscapes*), made the military use of spectacular western desert mountain ranges a public issue with their haunting images of gravely wounded land that had been disfigured by thousands of conventional bombs and strafing runs or would now be contaminated for centuries after decades of nuclear explosions.

Data only recently compiled by the National Cancer Institute show that thousands of people in twelve states east and north of the Nevada desert where atomic bombs were tested were exposed to high doses of fallout from those tests—and the government has yet to construct a permanent repository for the nuclear wastes generated during the making of those bombs.

The irony Misrach and Goin set before Americans was stark: Here stood the United States, the only country in the world so strong it had never been invaded by a foreign enemy. But, while protecting themselves, Americans had in part invaded themselves.

Terry Evans, another photographer of stature to address the problem of military sprawl, furthers our understanding of the ethical contradictions Americans so unwittingly

2

provoked in defending their shores. Her accomplishment has been to create the first comprehensive photographic portrait of a very different sort of half-century-old military landscape, one that, though almost omnipresent in the center of the nation, is still so little known that even its name—"GOCO"—is an oddity to most ears. GOCO, a World War II invention, stands for Government-Owned, Contractor-Operated, and GOCO sites are vast military factories.

They have their own special irony—because, though largely unmarked by destruction, they constitute a series of hugely successful places that for decades have been peacefully producing substances that can destroy other places thousands of miles beyond the GOCO horizon. As catalysts of violence, rather than its victims, GOCO sites have stories to tell, as Evans demonstrates, that differ markedly from what is found in other military landscapes.

BRINGING GOCO INTO FOCUS The Joliet Army Arsenal, the particular GOCO landscape 40 miles southwest of downtown Chicago that Terry Evans introduces us to, was once the world's largest TNT factory, an enterprise so ferociously efficient that at its peak it produced every week the explosive equivalent of 290 atomic bombs similar to the one dropped on Hiroshima. The two industrial installations at the Joliet Arsenal, the chemical works and a bomb assembly plant, were part of the 1940 "first wave" of twenty-nine GOCO plants (the total crested at seventy-seven three years later). The first wave was an urgent response to the fall of Paris, overrun by Nazi troops in June 1940—a defining moment when it became inescapably clear that the United States, which had once longed never to fight in a world war, must, for the world's sake, take the same leading part in the second of those wars that it already had in the first.

The national array of GOCO factories, which once occupied about 1.5 million acres, has been casting off invisibility largely in retrospect. In post–Cold War days, the military no longer needs most of them, and pressing thought must suddenly be given to the future of vast tracts of public land that, unlike the damaged arid lands of the West, are often next door to great numbers of people. GOCO factories, like conventional factories, need roads,

railroads, and reliable water supplies, so most of them are found within, or close to, metropolitan areas—especially now that so many metropolitan areas, spreading across what was once countryside, have engulfed areas that are 100 and 200 miles wide.

GOCO buildings, one story high, are somewhat larger than conventional factories—for safety reasons GOCO assembly lines needed plenty of elbow room. What sets GOCO factories apart from the rest of the industrial landscape is that they themselves had to be set apart: For both safety and security reasons, every 10 acres of buildings are surrounded by at least 60 to 100 acres of fenced-off buffer lands. The rusting Joliet factories, for instance, were so enormous that they needed to be surrounded by more than 19,000 acres of open lands—fields, pastures, prairie remnants, woods, and streams—that the public hasn't seen for nearly 60 years. Even the military itself has scarcely glanced at them. These are "brownfields" with a huge, green difference: abandoned industrial sites that, like other former factories, may or may not have toxic waste areas requiring cleanup but which, unlike almost any other factories, invariably bring with them a superabundance of unpolluted landscapes bursting with health.

GOCO sites are probably the country's largest "secret garden"—open land that since 1940 no one has been able even to think about building on or altering in any way. For strategic reasons that had a compelling logic in 1940, most GOCO factories were in the heartland of the United States, beyond the reach of either the Luftwaffe or the Imperial Japanese Air Force. The preferred locations were west of the Appalachians, east of the Rockies, and at least 200 miles from either Canada or Mexico. Because the land needed for GOCO factories was within already settled areas, the military had to buy it, rather than "withdraw" it from the government's store of empty western spaces. And, as Terry Evans shows us, there it still sits—a great assemblage of untouched, prewar farmland and wildland that already belongs to all of us.

And that also, as it happens, is right where we need it—since it forms the backyard of tens of millions of post–Cold War city dwellers and suburbanites hungering for open space nearby. What is to be done with this unexpected peace dividend? It is a question that, though it has not emerged as a national issue, has recently been so intensively scru-

tinized and debated by people in the Joliet area that national programs are likely to copy their results. The Joliet Arsenal landscape, as this book celebrates, is about to undergo an unlikely but astounding transformation. A butterfly that once spent time as a caterpillar will return to being a butterfly.

WHEN GOCO SPELLED HOPE Look closely, and you'll see that all of Terry Evans's photographs capture two moments of destiny and shimmer with two sorts of hope and possibility. People today are holding their breath to see what will happen next at Joliet and on other GOCO lands the military is letting go of. But an earlier generation once held its breath to see if setting up GOCO lands could help the country stand up to Hitler's cruelty. Before the fall of Paris, this country had a small peacetime army and only "enough powder," it was later said, "to supply our 1943 troops for one day."

Mobilizing for World War I had made it painfully clear to U.S. Army planners that it was far easier to raise an army than to equip it—troops can be conscripted and trained within months, but regearing factory production to turn out enough guns and ammunition takes at least a year and a half. The supply side of war, as Kimberly L. Kane, a GOCO historian, points out, is a matter of "great complexity," compounded by its "enormous scale." Riding to the rescue of Britain and France in 1917, the United States was so ill equipped that it arrived, Kane has written, with "more guns than gun carriages" and, humiliatingly, had to buy supplies from the British and the French.*

The GOCO concept was devised by army planners in 1920 to make sure that the United States would never be caught short again. But to some it seemed a terrible gamble. Americans were tired of war. German and Japanese war planners in the 1930s thought the United States had become fatally weak, saddled by citizens who were, as Kane put it, "too competitive, disunited, isolationist and materialistic to cooperate with each other and make the sacrifices necessary." A second risk in GOCO planning was that it relied almost entirely

*Kane is the author of *Historic Context for the World War II Ordnance Department's Government-Owned Contractor-Operated (GOCO) Industrial Facilities, 1939–1945*, an official history of the GOCO sites, recently published by the U.S. Army Corps of Engineers, which sets forth this and many other accounts.

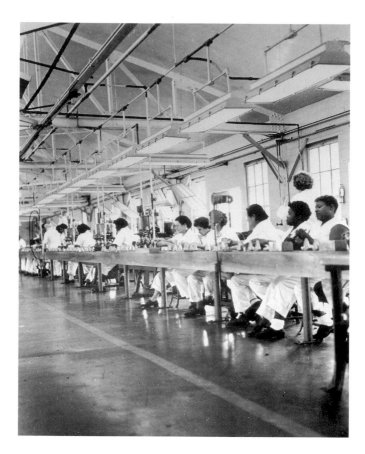

World War II production line in Joliet Ammunition Production Arsenal factory. Ran in *Chicago Tribune* during Korean War, March 3, 1960. By staff photographer. Reprinted with permission.

on private industry moving into newly built, publicly financed factories—and American businesses, in the 1930s, didn't make armaments, except guns for hunters, farmers, ranchers, and policemen. The army's assumption—a shrewd one, as it turned out—was that skill in mass production was more important than expertise in mass destruction. A GOCO worker quoted by Kane later said that assembling bombs and shells was very much "like putting sugar in a bag, except you have to be more careful."

Time was the final unknown in the GOCO strategy: Once the country was finally committed to rearming and had discovered that chewing gum makers, soap manufacturers, cereal companies, and soft-drink bottlers could handle the job, would it be given the

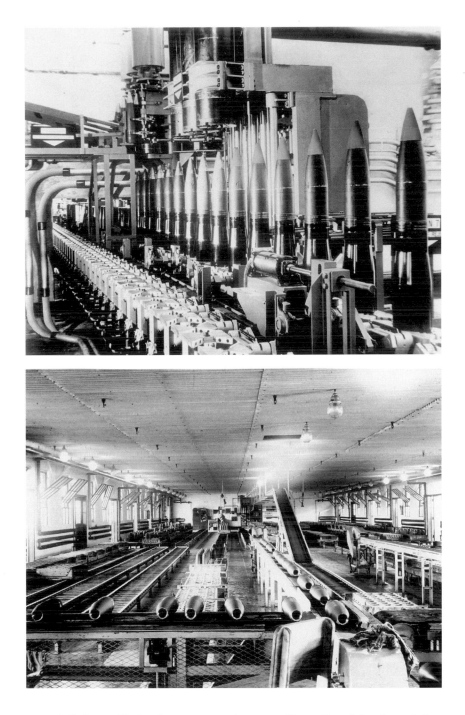

Top, Shells being filled with ammunition during World War II, at Joliet Arsenal. Ran in *Chicago Tribune*, June 12, 1958. Bottom, Conveyor belts at Joliet Arsenal, World War II. Ran in *Chicago Tribune*, March 3, 1960. By staff photographer. Reprinted with permission.

required eighteen months to assemble what was needed before the enemy opened fire? Construction crews went on overtime and added extra shifts. As it turned out, almost exactly eighteen months elapsed between the fall of Paris and Pearl Harbor—and the United States was able to enter World War II with firepower to spare.

America fielded 8,290,000 troops during the war, and each platoon of soldiers used as much ammunition as an entire division of Civil War troops. During the course of the war, GOCO factories sent arms to forty-three Allied countries. Dismantling this mighty military-industrial machine and putting the genie back in the bottle has proved far more problematic. The task of extracting new hope from the GOCO sites, thanks to the fall of the Berlin Wall, is now in the hands of the grown children of the men and women who fought in World War II. What the 1920 army planners didn't foresee is that their GOCO factories might perform remarkable services to America twice over—saving the lives of one generation and now enriching lives that will blossom in a new century.

ANSWERING AN OLD QUESTION: HOW CAN THIS PIECE OF LAND SERVE US BEST?
The "land-use question," as planners call it, is a human constant, resounding down the centuries as successive waves of people, each with their own needs and perceptions, roam the world. For white settlers, men and women, many of them former New Englanders, who in the early nineteenth century poured into the bountiful new state of Illinois—a state almost as large as the whole hardscrabble, six-state region they had just left behind—the land-use question had a clear, ringing answer. They saw the prairie and its tall grasses and bright flowers and immediately had no doubts that its highest and best use was to give way, making room for productive farmland.

So the Joliet-area settlers sliced away the skin of the prairie from the top of the land and began living off the body of the prairie underneath it. That wasn't how they put it to themselves, of course, but the rich, black dirt they had just uncovered, among the most luxuriant soil in the world, was in fact prairie-formed, the afterlife of prairie plants, some of them centuries old, that had accumulated over thousands of years.

A hundred years later, GOCO planners in Washington, D.C., poring over maps of the Midwest, saw things just as clearly—and completely differently: The farming area near Joliet met all the criteria they had generated during twenty years of study and was ideally suited for making high explosives. They bought up 150 Joliet-area farms in July 1940 and within fourteen months were turning out 50-pound blocks of TNT, a yellow crystal that then got stuffed into bombs, artillery shells, and land mines. A half century later, the land-use question for this same Joliet-area property became the responsibility of the arsenal's neighbors, men and women from the Chicago region who had come to realize that the big state they live in is also part of an increasingly small planet.

They, too, have found a compelling vision for this place. They listened to the land, walked it, consulted with it directly, experiencing for themselves its vastness and solitude. Despite initial disagreements, they unanimously decided that the best contemporary use for most of this land was to put aside the important jobs formerly entrusted to it—feeding the world and keeping it safe for democracy—so it could take up its own work and once again be a prairie.

The idea began a quarter of a century ago, and very quietly, among a few people, some of them at Openlands, a Chicago-area conservation and recreation group that was then ten years old, who saw that a large green oasis to the south could nourish an entire urban region. Scientific documentation of the site began in 1982, when a group of naturalists at the Illinois Department of Natural Resources recognized that nowhere else in the state could grassland birds hope to find a haven of this size. And in 1993, when the formal, twenty-four-member Joliet Arsenal Citizen Planning Commission convened, members found that they could slowly build trust among themselves by staying focused on the fact that if they didn't work together something precious would slip away—and that if they did they could accomplish something they would be proud of.

The Bible exhorts us to turn our swords into plowshares—but this new project is even more of a stretch. One of the project managers calls it "a once-in-eternity opportunity." Another refers to it as "turning bullets into birds."

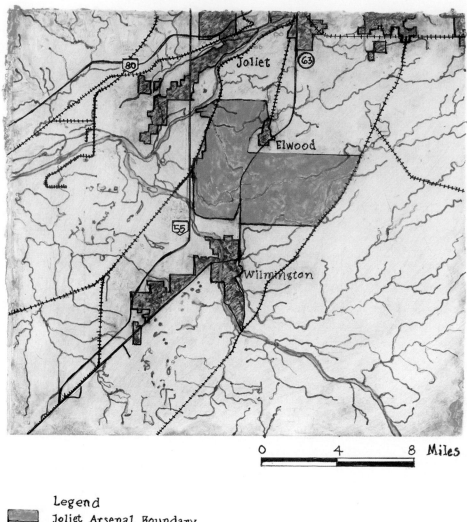

0 4 8 Miles

Legend
Joliet Arsenal Boundary
Municipalities
Streams
Roads
Railroads

N

Joliet Arsenal and Surrounding Area. Map by Karen McCoy, 1997.

HEALING SOCIETY On March 10, 1997, a great swath of Joliet Arsenal land took on a new name, becoming the Midewin National Tallgrass Prairie. On the same day it got a new landlord, the United States Forest Service, which already had specific instructions from Congress to create a federal ecological reserve on the site and to begin rebuilding the prairie at once. "Midewin"—which is pronounced "Mid-*day*-win"—is a word that comes, with permission, from the language of the Potawatomi, the American Indian nation that cared for and cared about Chicago-area prairies until the 1830s, when they were displaced by families of white settlers moving west, the same families who a century later would themselves be displaced by the GOCO planners. To the Potawatomi, "Midewin" means "healing society," the process of mending, soothing, and making whole again, until someone or something is as good as new.

The Joliet Army Arsenal was so immense that every worthwhile public purpose put forward during the planning process was, in the end, accommodated—so that, as a result, 1,000 acres of former arsenal land will be hallowed as the new Lincoln National Cemetery, a burial ground for veterans and their families, bigger than the national cemetery in Arlington, Virginia; two new industrial parks will be sited on 3,000 acres; and almost 500 acres have been set aside for a new Will County landfill. And within Midewin itself, the 19,000 Joliet Arsenal acres that have now been dedicated as a prairie park, the land is taking on so many purposes to accomplish and promises to keep that the following, astonishingly, is only a partial list.

As a natural area, Midewin will be America's first national prairie park, the largest tallgrass prairie east of the Mississippi River, and a national park whose underlying purpose is global—and where the needs of the hosts, the resident plants and animals, are as sacrosanct as those of human guests; a permanently protected piece of a keystone ecosystem in North America, once the most abundant landscape on the continent and now one of the most fragmented and imperiled; and as such an inalienable home for North American grassland birds—the shorter-grass-loving bobolinks, upland sandpipers, harriers, and short-eared owls, and the longer-grass-preferring meadowlarks and song sparrows that in

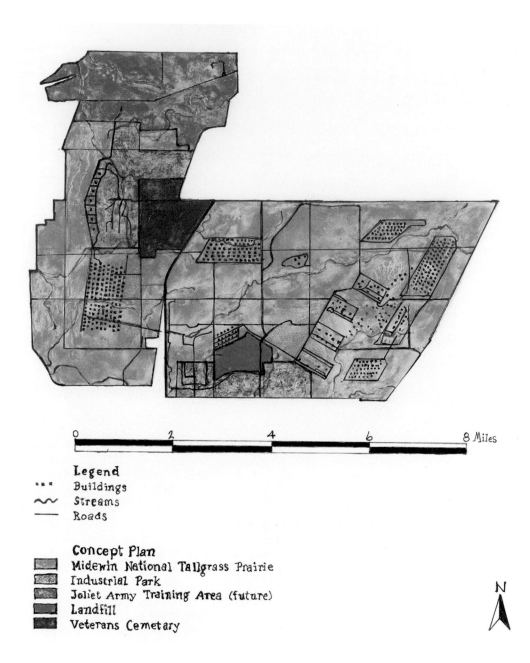

0 2 4 6 8 Miles

Legend
▪ ▪ ▪ Buildings
∿ Streams
— Roads

Concept Plan
▭ Midewin National Tallgrass Prairie
▭ Industrial Park
▭ Joliet Army Training Area (future)
▭ Landfill
▭ Veterans Cemetary

N

Midewin Site. Map by Karen McCoy, 1997.
She used soil samples from the Midewin site to color this map
and the map of Joliet Arsenal.

the 1980s all went into steeper and more widespread declines than either forest birds or waterbirds.

In addition, Midewin will anchor an even bigger protected landscape, the "Prairie Parklands Macrosite," 62.5 square miles of contiguous and undeveloped public and corporate land—prairies, forests, and wetlands, some reclaimed, others that have never been disturbed.*

As a recreational resource, Midewin will be the central oasis in the Illinois & Michigan Canal National Heritage Corridor, Illinois's 100-mile-long resurrection of the landscape that helped to create Chicago, representing a nationally established partnership of historic local communities that maintain the highest concentration of presettlement landscapes in the state; it will offer visitors a type of wilderness experience that until now seemed extinct: one that blends land and air, solitude and immensity, lushness and the ruggedness of searing summer heat and almost constant wind—that is to say, total immersion in a vast tallgrass prairie of the kind that disappeared from the Midwest a hundred years ago and will now be within a day's drive of 100 million people.

When Midewin opens, 4 million people a year can walk and hike among free-roaming herds of both bison and elk—the traditional large grazing animals of eastern tallgrass prairies—which can be safely reintroduced at Midewin because the army, to keep marauders out, years ago surrounded the entire property with 37 miles of strong chain-link fence.

Since it takes at least a century to grow an inch of mature prairie soil, Midewin National Tallgrass Prairie is probably best described as the world's first twenty-second-century park. It will open its gates early in the twenty-first century—for what will amount to a century of previews.

*Beyond the "Prairie Parklands Macrosite," there's an even wider archipelago of protected ecosystems, a sum made up of almost two dozen additional publicly owned natural areas, all of them within a 12-mile radius of Midewin.

WHAT'S IN A NAME For at least the last two generations in America, many newly coined real estate names (such as "Green Meadows," "Orchard View," "Quail Run," or "Prairie Acres") have shamefacedly pointed away from the future, telling us what a piece of property may once have looked like—but no longer can. Such names have carried with them a hidden, nothing-you-can-do-about-it-now message, reinforcing the notion that all changes to the land—those one embraces, those one loathes—are irreversible.

Midewin proclaims the polar opposite—it asserts that local initiative can reverse the seemingly irreversible. Making no distinction between the deep past and the long-term future, it reconsecrates a landscape continuity that's stronger than even generations of upheaval and forgetfulness.

HISTORY OF A ONCE AND FUTURE PRAIRIE The two wrenching, no-appeals-allowed, nineteenth- and twentieth-century changes Midewin has been put through—prairie to farmland, farmland to bomb factory—have never been as final as they originally may have felt. Memories of prairie days faded, but scraps of native prairie survived at the edges of farms, and many grassland birds stayed on and adapted to the hayfields and pastures that replaced the prairie. And large-scale farming continued to be essential to military occupation of the land.

Midewin, even now, is still mostly immense tracts of open land—some woodland but primarily cornfields, soybean fields, and livestock pastures, all of them threaded with streams that flow year-round. The core of the property has decayed—the old chemical plants, the factories, and the arsenal's most distinctive army-era feature, hundreds of oddly mounded concrete-and-earth TNT storage bunkers, called igloos in military slang. Midewin's safety zone of rented-out farmland is intact and has saved plants, birds, and people all at once. Midewin's greatest single tragedy, a violent explosion at 2:45 one morning in 1942, cause still unknown, would have been far worse without so much farmland. The blast killed more than forty munitions workers at the plant who were loading land mines into boxes, and it shattered shop and office windows in downtown Aurora, 30 miles to the northwest. (There were, thankfully, no fatalities beyond the arsenal's boundaries.)

Perhaps landscapes have longer memories than we can credit; perhaps ancient imprints are slower to fade. The discords and discontinuities at Midewin go back only about 160 years, through perhaps seven generations. But people's harmonious and mutually nourishing interactions with this landscape are already a tradition that's at least 200 generations old.

THE LINGERING PRAIRIE A prairie, "North America's most characteristic landscape," as Walt Whitman once called it, is the one principal building block of planetary biodiversity whose continuing health has, throughout most of the recent postglacial period, actively depended on continuing human interventions. The Illinois tallgrass prairies, in particular the spectacular grasslands that in many places grow high enough to hide a herd of bison, can be thought of not just as a natural phenomenon but as one of the primary early accomplishments of human culture—and one that, like the Great Wall of China, could actually be seen from outer space. If one looks at a map of America's presettlement prairies, there's one immediately obvious anomaly, a sort of big, bright green bump bursting out beyond the northeast corner of what is otherwise largely an east-of-the-Rockies but west-of-the-Mississippi landscape.

This bump is Illinois, the "Prairie State"—or the "prairie peninsula," as biologists call it—meaning that it is an island of grass almost entirely surrounded by forest. At the time Illinois became a state, in 1818, it contained almost 9 million acres of tallgrass prairie—a stunning domain, the pinnacle of prairies, a wild magnificence, a windswept, unshaded, and humbling place that so far has been sadly undercut by the language it has been packaged in. The word *prairie*—well, we're stuck with it, even though it's really only a for-want-of-a-better-word; *prairie* is French for "meadow"—a word that, to the French, conjures up something beautiful but completely domesticated, exemplified by the all-green, cool-weather-liking, short-grass landscapes of the Ile-de-France.

It's like calling a bison a shaggy cow. Louis Joliet and Father Jacques Marquette, taking a shortcut home to Canada through Illinois after discovering the Mississippi, were officially, in 1673, the first Europeans ever to see the grasslands at the center of the American

continent, and, as these men paddled by in their canoes—getting quite close to Mide-win at one point—*prairie* was the first word that flashed through their minds. Illinois enchanted them—"an earthly paradise," they called it.

THE PRAIRIE CARETAKERS Tallgrass prairie could as accurately be called tallflower prairie, since its waves of green are also the rich setting for every other color in the rainbow. (Three-fifths of tallgrass prairie plants are grasses, while the other two-fifths are wildflowers.) This lush landscape originally had a driving biological and meteorological basis: Eight thousand years ago, a shifting climate of warmer, drier weather made it possible for grasses to shift east out of their Great Plains stronghold and to invade what were then four-thousand-year-old, postglacial Illinois forests. But three thousand years later the climate changed again, getting cooler and wetter, bringing, as it still does today, up to 43 inches of precipitation a year to Illinois. This continuing, modern climate is a standing invitation for the reencroachment of trees—which means that for five thousand years every Illinois prairie has been a woodland-in-waiting.

But for the would-be woods in Illinois, waiting never ended, because another force, stronger than climate, came into play. Grassland wilderness lingered in the east, as a new kind of watchfulness extended over Illinois. For the next five thousand years successive communities of American Indians helped to hold the Illinois prairies in place by faithfully setting them ablaze nearly every spring. Prairies cannot survive without either grazing animals or periodic fires; these are the pruning agents that help prairie grasses and flowers regenerate, while at the same time holding at bay the trees that would otherwise crowd them out. The fires set by the Indians were by no means the only force sustaining Illinois prairies—wildfires played their large part; bison and elk were essential grazers; and periodic droughts, which grasses could tolerate, were lethal to saplings.

But these prairies need people the way gardens need bees; and we can now recognize the actions of Illinois's Native Americans as one of humanity's earliest and most durable partnerships with the planet. Their long wakefulness helped to keep the land open and flowering. And Midewin's new healers, when they bring back the great prairie grazers and

relight the prairie fires, will be reaffirming an interrupted tradition, rekindling an ancient pact and alliance between people and place.

TWO WAYS TO GET CLOSER TO MIDEWIN In Terry Evans's photographs of Midewin, we see human traces—everywhere—but no human faces. The land itself, and two hundred generations of people, are telling us a story of changes that have been left behind and of a renewal that is about to begin. Ms. Evans has created for us an intelligent and meticulous record of Midewin's present moment—a hushed, between-breaths pause in the life of a historic landscape. The military has moved on; the prairie healers are about to move in. At Midewin we see a place that is poised, waiting, at its turning point, about to flow back into the pattern it was diverted from but never quite deserted.

There's a pressing national need for more Midewin-style processes around the country. This book shows—just as the earlier American Indian prairie caretakers demonstrated— that people can be every bit as persistent, accommodating, prudent, and resourceful about keeping special places special as they can about turning them into something unrecognizable.

A process that is based on fact, experience, trust, and leadership has an excellent chance of success. When the right piece of land gets inside people's hearts, big-heartedness and open-mindedness can help us to weigh the choices before us and to see the true value in landscapes such as the one Terry Evans so luminously sets before us in this book.

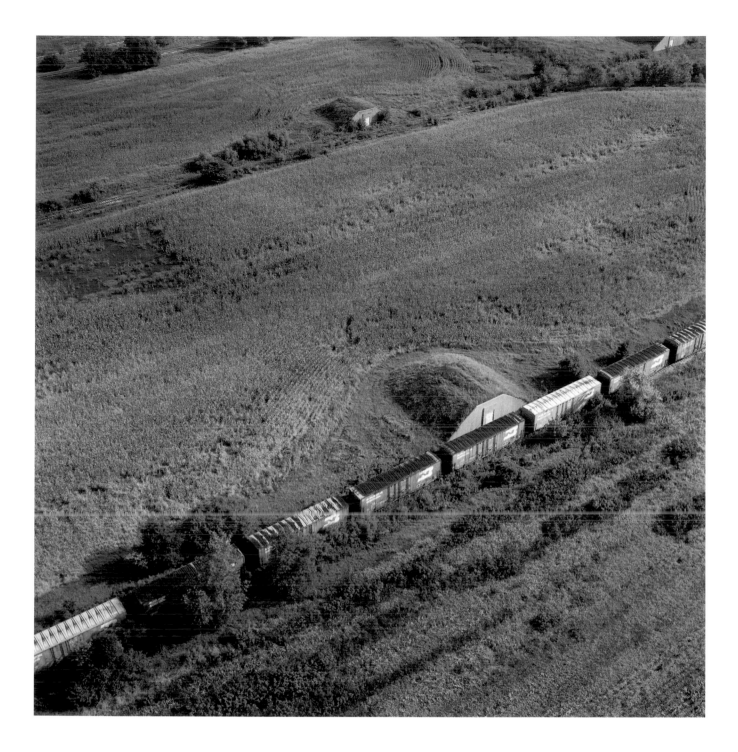

Abandoned bunkers and train, now a cornfield, September 1995.

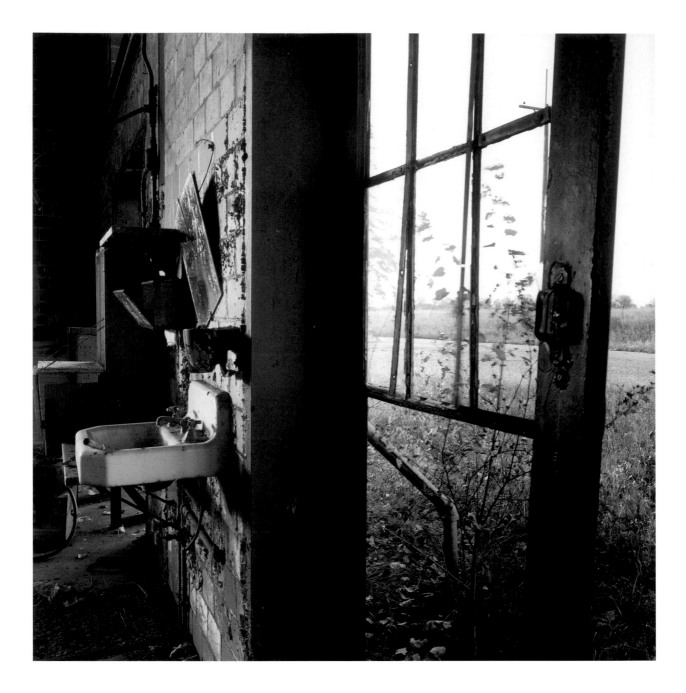

Furnace room (sink), east side, October 1996.

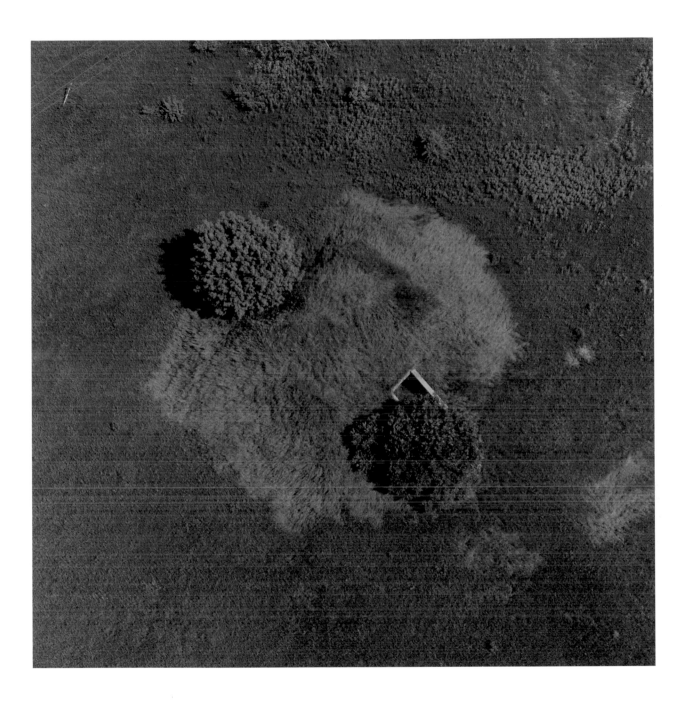

Ammunition storage bunker, July 1996.

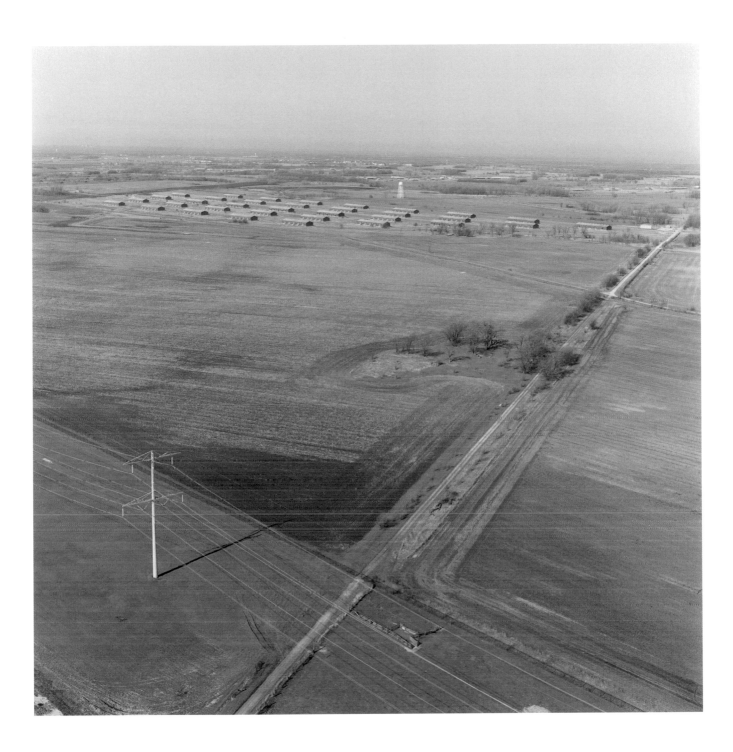

Looking west/southwest from the east boundary
at aboveground magazines where finished munitions
were stored, May 1997.

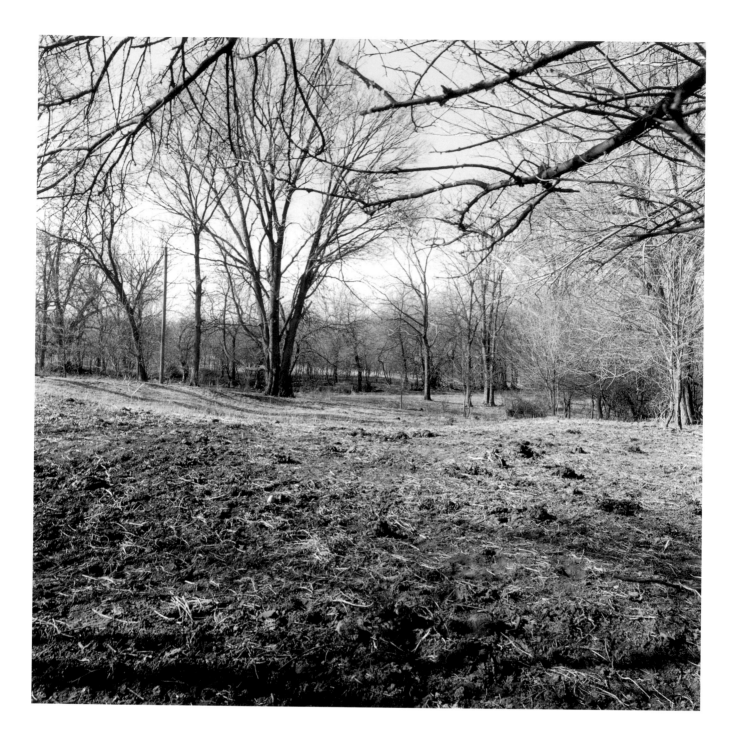

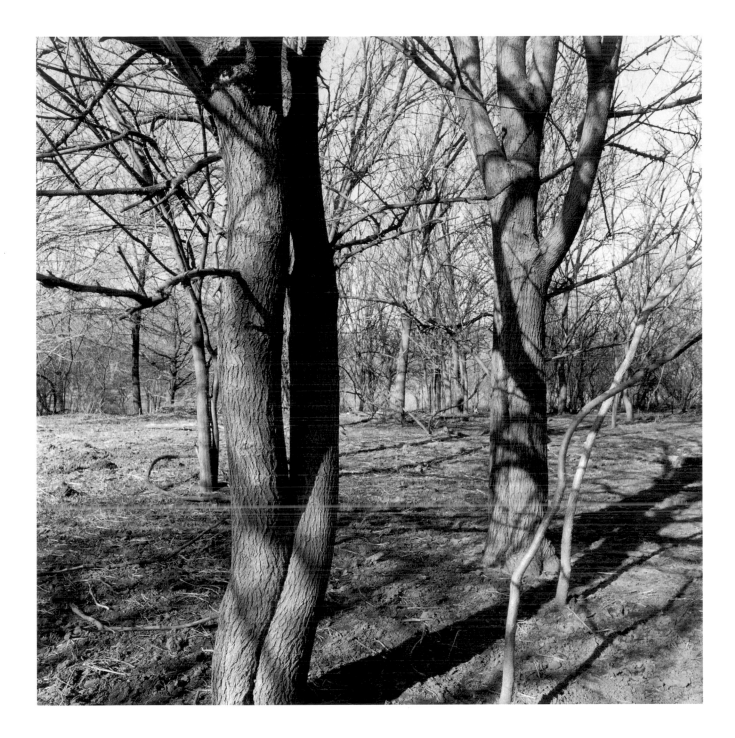

Vicinity of the Plenemuk prehistoric burial mound, January 1997.

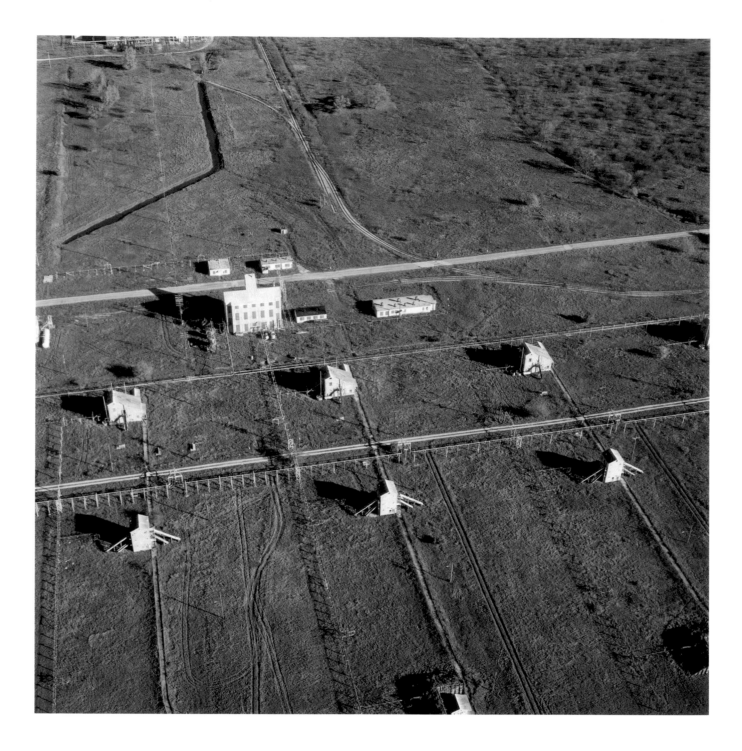

Manufacturing area, west side, will be the new Deer Run
Industrial Park, October 1995.

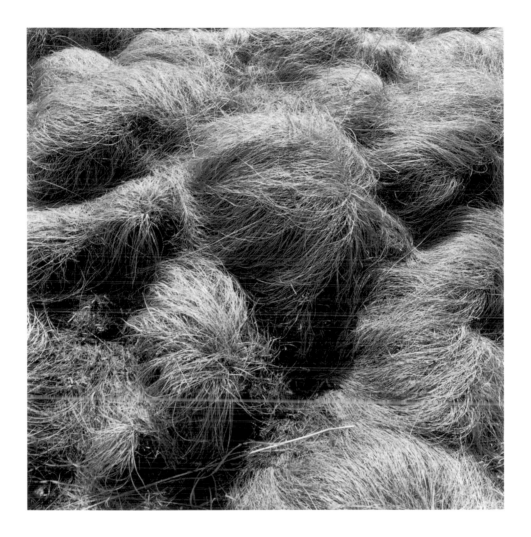

Drummond Prairie, dropseed grass, March 1997.

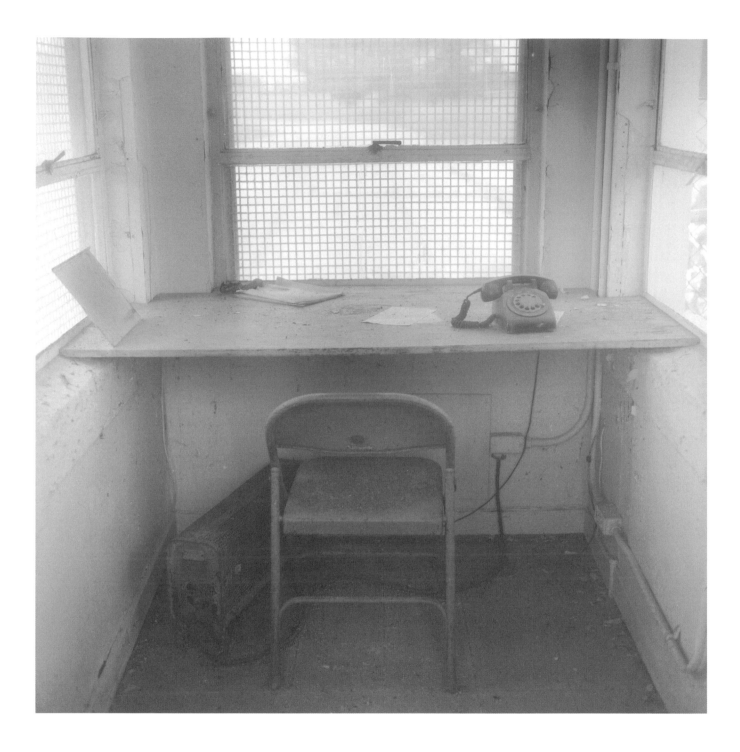

Guard house interior, noncommissioned officers' housing,
July 28, 1996.

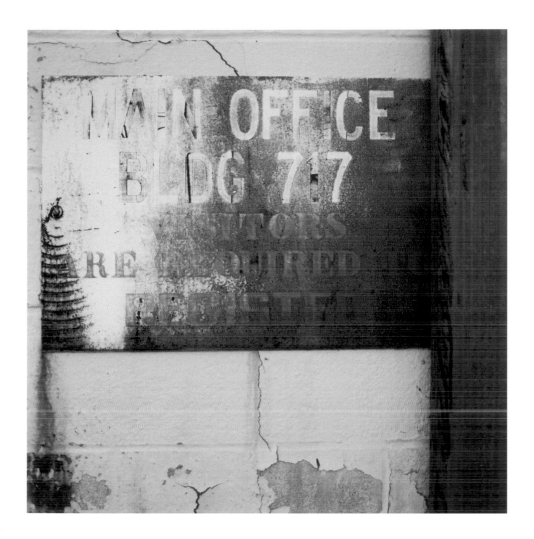

Abandoned main office building, west side, August 1, 1996.

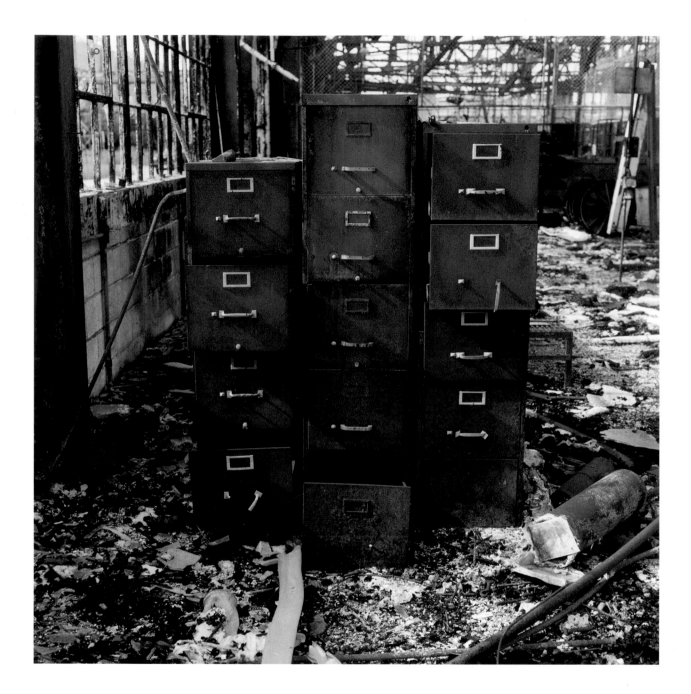

Abandoned main office building, with file cabinet, destroyed
in December 1995 by fire, August 1, 1996.

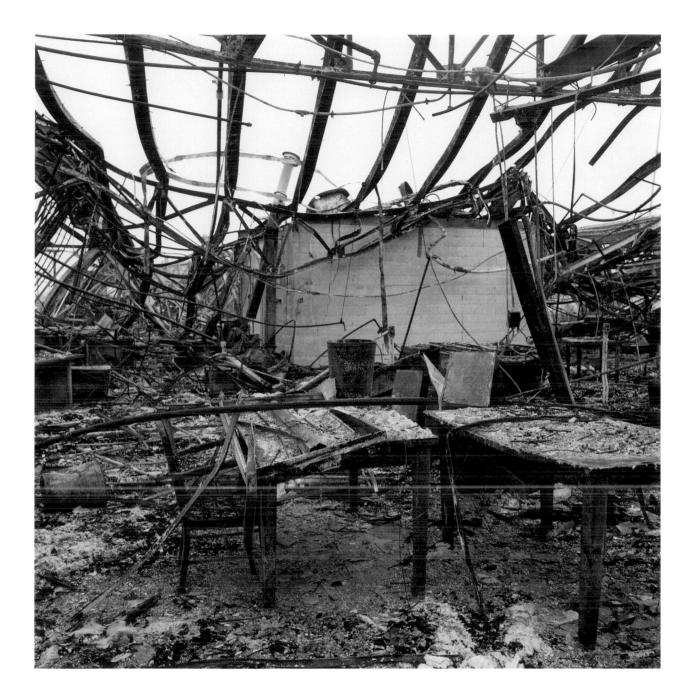

Abandoned main office building, with table and chair, destroyed
in December 1995 by fire, August 1, 1996.

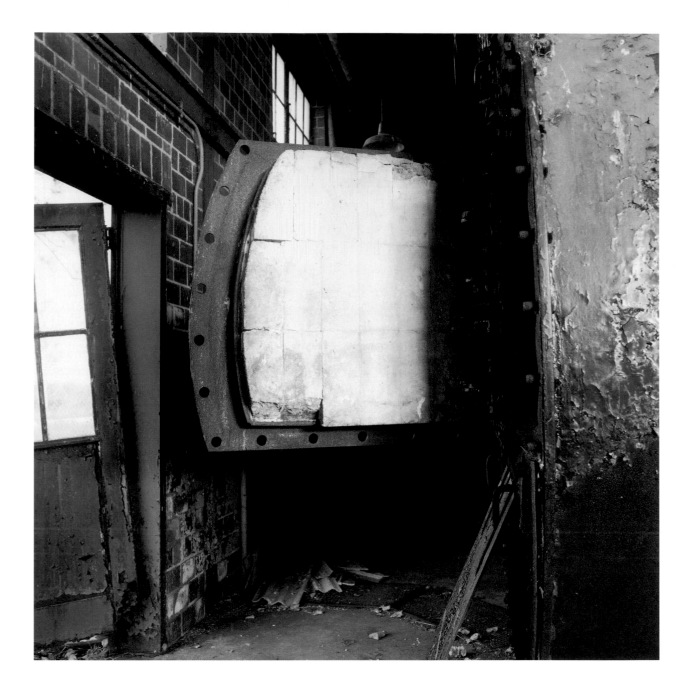

Furnace building, with door, east side, October 10, 1996.

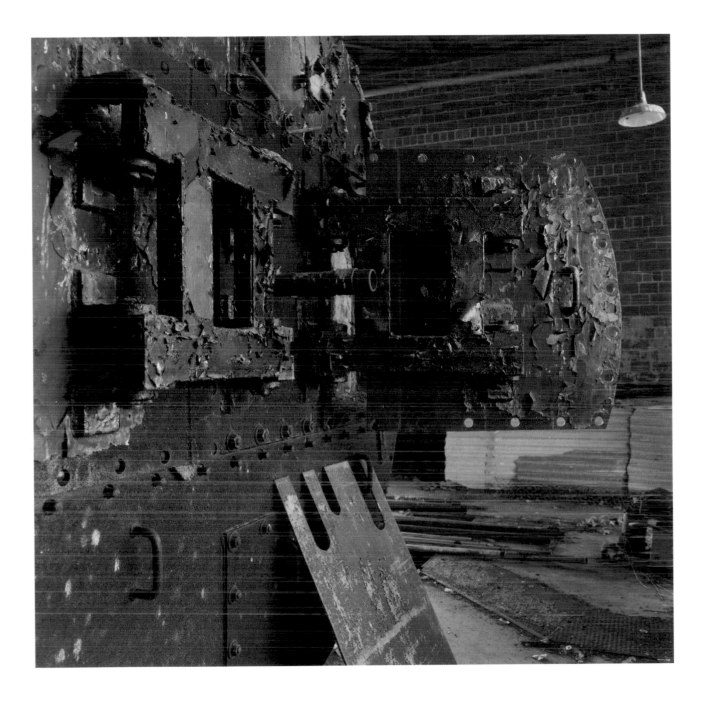

Furnace building, with light, October 10, 1996.

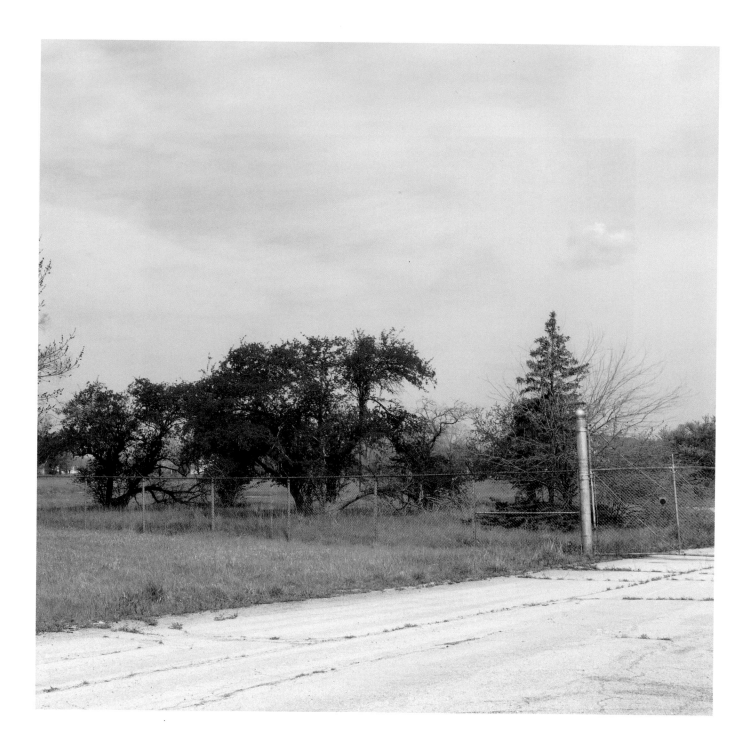

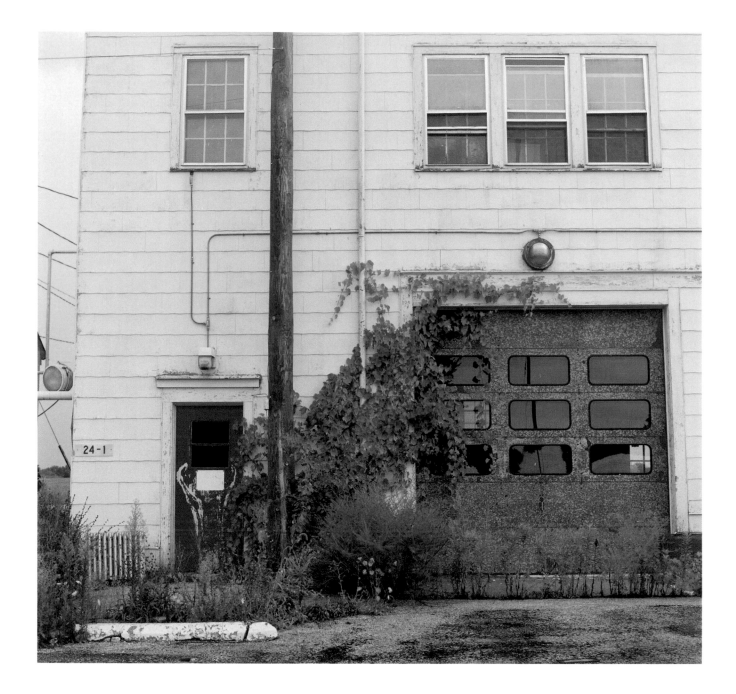

Fire station, August 22, 1995.

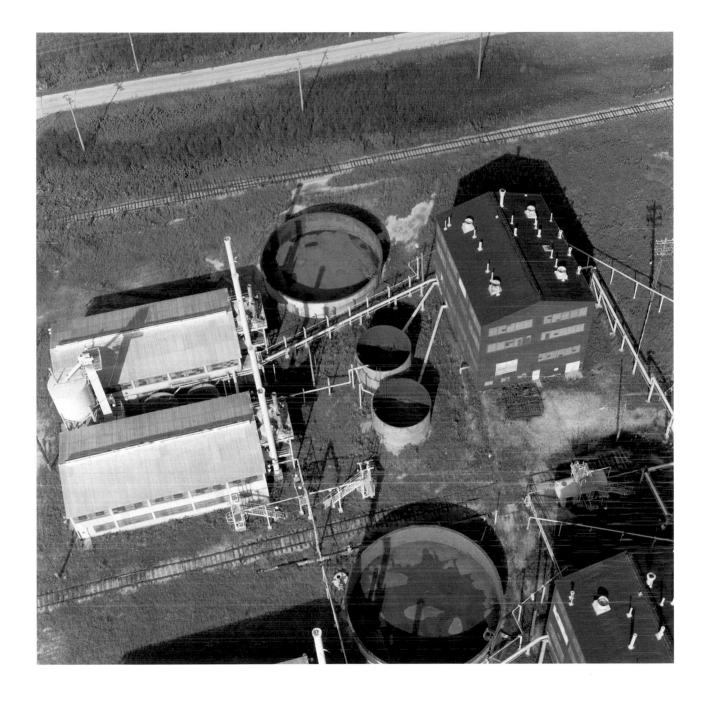

Vats in the manufacturing area, the west side,
September 9, 1995.

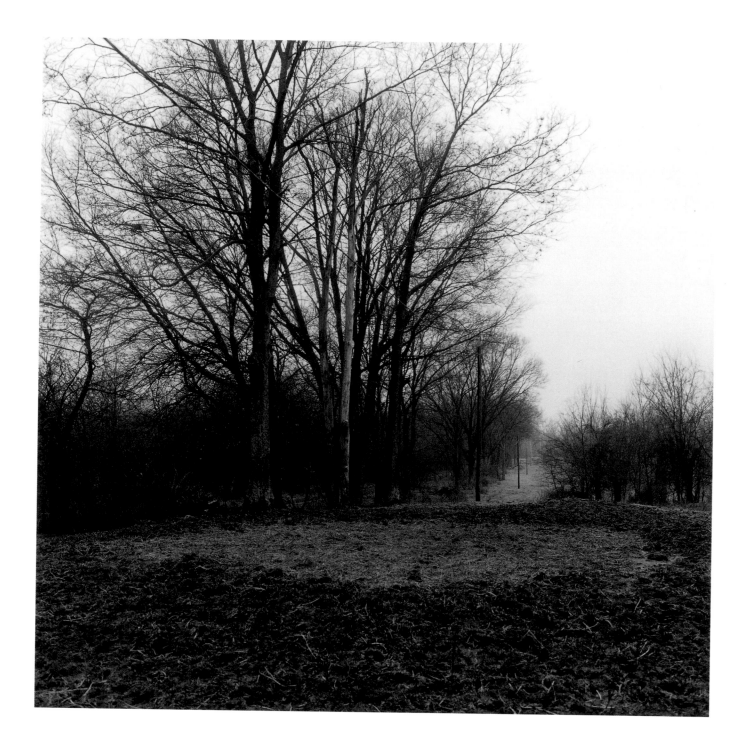

Feed for cattle adjacent to the Plenemuk burial mound,
January 1, 1997.

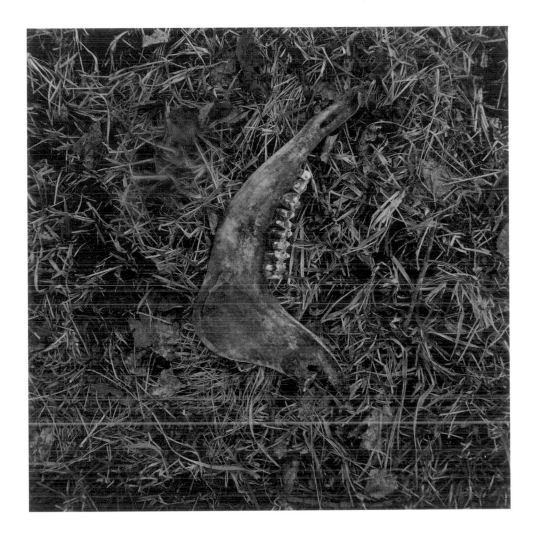

Jawbone of a deer on the Plenemuk prehistoric burial mound,
March 1997.

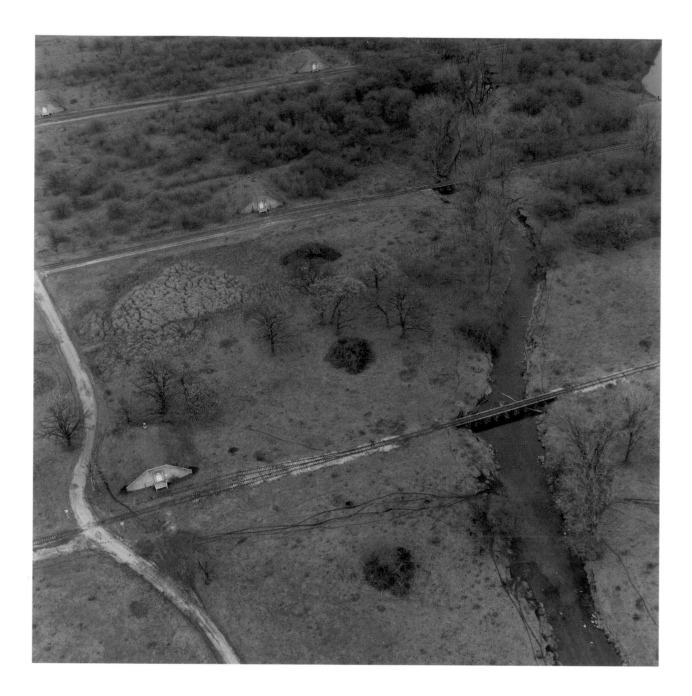

Wetland and Prairie Creek on School House Road,
November 25, 1996.

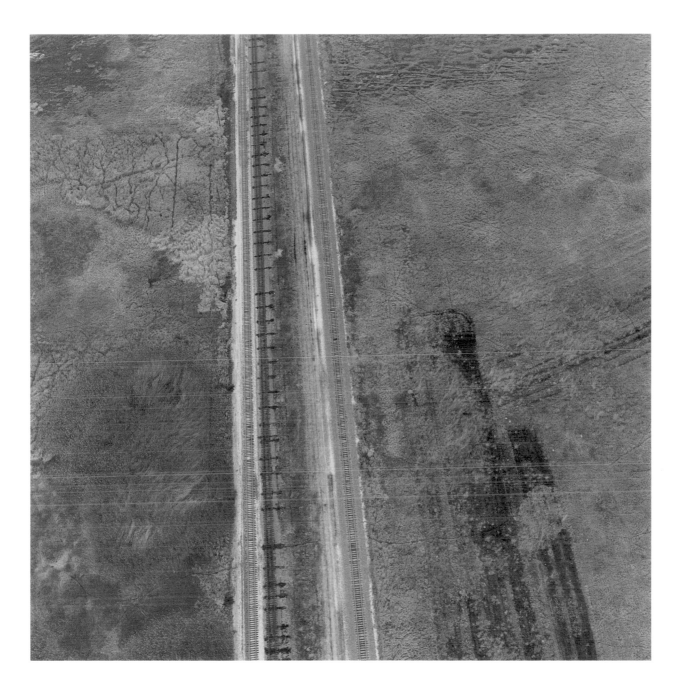

Railroad tracks next to Drummond Prairie, November 25, 1996.

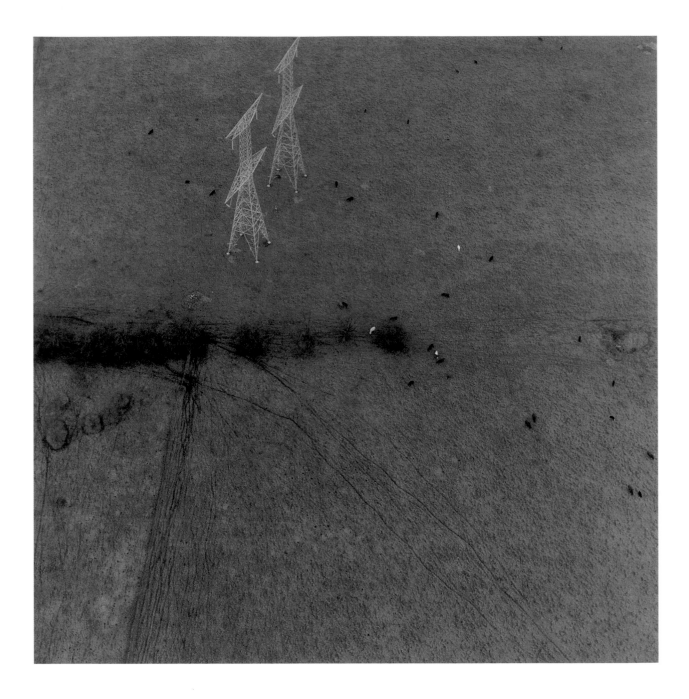

Power lines and cattle, November 25, 1996.

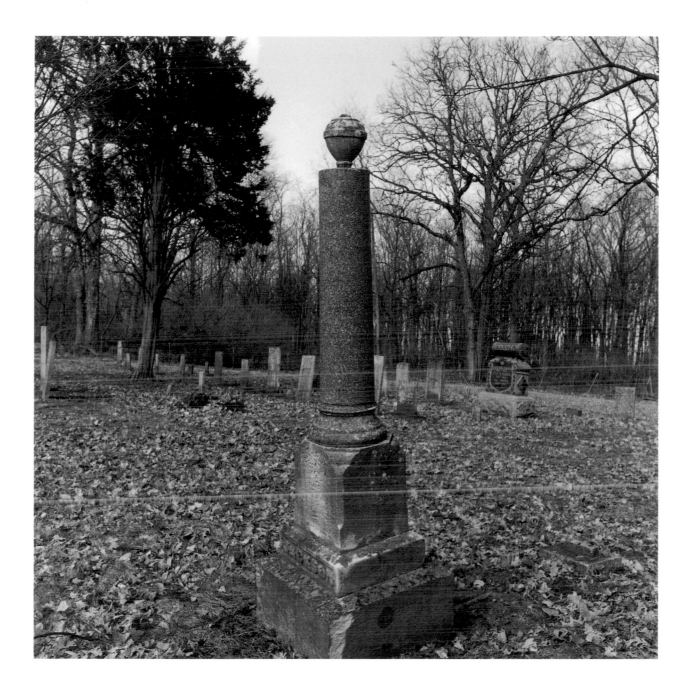

Starr Grove Cemetery, March 28, 1997.

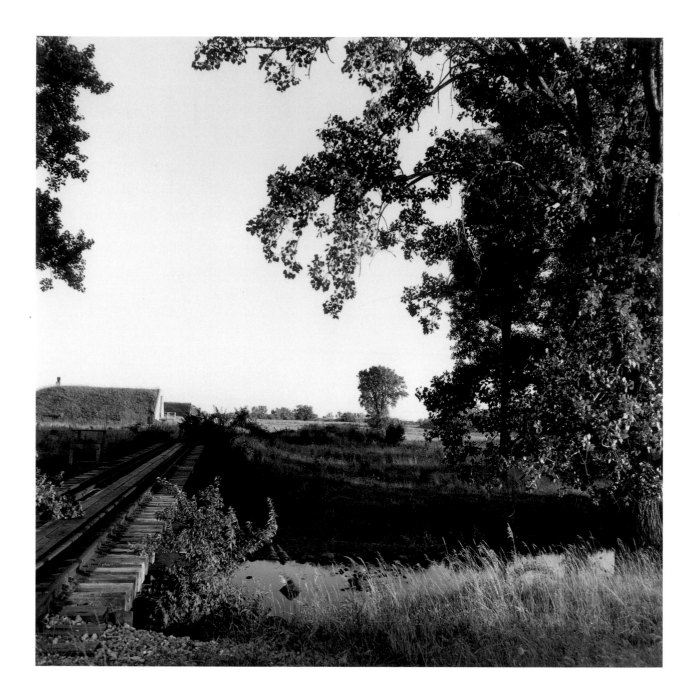

Narrow gauge railroad tracks over Prairie Creek, July 1995.

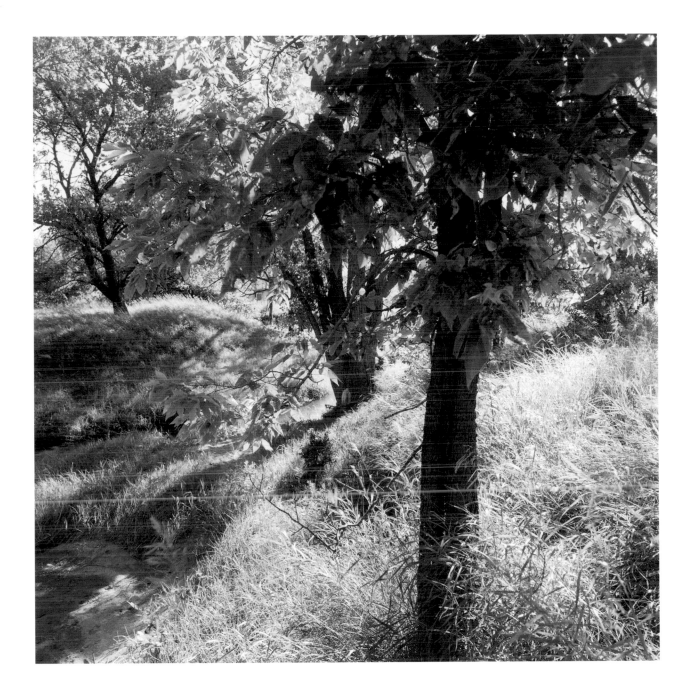

By Prairie Creek, Sunday, July 28, 1996.

THE BEST PART about doing this book project, next to photographing the land, was the experience of being part of an idea that involved generous people who give large parts of their lives toward saving land. I am most of all indebted to Jerry Adelmann, director of Openlands Project, whose organization facilitated support for these photographs. Countless conversations with him shaped every part of this project except for the photographs themselves, which he unreservedly left to my own judgment. For his dedication to this book project, I am grateful. The U.S. Forest Service made these photographs possible through its financial support, and Dr. Lawrence Stritch, Macro Site coordinator of the Midewin National Tallgrass Prairie, generously gave me access to the entire Midewin land. The Midewin National Tallgrass Prairie staff cheerfully and expertly informed me in many ways. Thanks to Linda Sasamoto, who constructed the computer-generated maps that were the sources for the hand-drawn maps. I'm grateful to artist Karen McCoy, Sculpture Department at the Kansas City Art Institute, who not only drew the lively maps but also colored them with soil samples, which she instructed me to collect from various parts of the Midewin site. Ecologist Jack White, who has studied every square foot of land there, introduced me to the former Joliet Arsenal and explained aspects of its natural history and ecology. Others have informed me about the land, especially Fran Harty and Bill Glass of the Illinois Department of Natural Resources. James Please, a farmer who has leased grazing land there for thirty years, showed me that land on his tractor. I'm indebted to conservation-minded pilot Steve Keibler of Delta Airlines, who took me half a dozen times to do aerial photography, donating both his expert flying skill and the use of his Piper Cub. Thanks also to Dave Mercer, who donated his piloting time and plane.

ACKNOWLEDGMENTS

I'm grateful to the staff of the Johns Hopkins University Press for exacting care, and especially to designer Glen Burris. For great patience, I thank Randy Jones of the Center for American Places. Thanks to Melissa Sharp Leasia of Openlands Project for her attentive work. For the book's title, I acknowledge the *Chicago Tribune Magazine*, May 10, 1996.

Other colleagues, friends, and family have helped me in invaluable ways. I'm indebted to Greg Conniff for generous counsel and support at every phase of this book. For looking at the photographs and helping me think about them, I'm indebted to May Castleberry, Merry Foresta, Saralyn Reece Hardy, Joel Snyder, Alan Thomas, David Travis, and John Szarkowski. I'm also grateful to David Evans, Tony Hiss, and Norman Hoyt for reading the preface and helping me realize what I wanted to say. Corey Evans, Sarah McNear, George Ranney, Vicky Ranney, and LeAnn Spencer each met me at a particular point in the progress of this project and accompanied me to the next point, just when I needed their help. Most of all, I'm grateful to Sam Evans for solidarity and insight along every step of the way.

Finally, I thank George F. Thompson, president of the Center for American Places, whose commitment and vision about land and landscape values and related books make me proud to be associated with him. I'm deeply grateful for his focused energy and attention to this book.

This book would not be possible without the generous support of Openlands Project, which has helped to protect open space in northeastern Illinois for the past thirty-five years. Openlands Project and I are especially grateful to the Mobil Foundation, Inc., who, at the request of Mobil employees in the Midwest region, have provided extraordinary support. Openlands Project and I are grateful to Chauncey and Marion Deering McCormick Foundation, Baird Foundation, Ridge Capital Corporation, La Salle National Bank, Victoria and George A. Ranney Jr., Kent and Marcia Minichiello, and Stephen and June Keibler.

TERRY EVANS

For the past twenty years, **TERRY EVANS**, a native of Kansas, has photographed the prairie from its native state to its use, abandonment, and restoration. Her work has been exhibited widely and is in the permanent collections of many museums, including the Art Institute of Chicago; the Museum of Modern Art; the National Museum of American Art, Smithsonian Institution; the Museum of Fine Arts in Houston; the Baltimore Museum of Art; and the San Francisco Museum of Modern Art. She has received numerous grants and fellowships, including a 1996 John Simon Guggenheim Memorial Foundation Fellowship and a Mid-America Arts Alliance/National Endowment for the Arts Fellowship. Publications of her work include *Prairie: Images of Ground and Sky* (University Press of Kansas, 1986) and *The Inhabited Prairie* (University Press of Kansas, 1998).

Terry Evans lives in Chicago with her husband, Sam. They have two children, David and Corey.

TONY HISS has been a staff writer for the *New Yorker* since 1963, for which he has written several hundred nonfiction reports, profiles, and reviews on a wide variety of subjects. He has also written pieces for *Newsweek, Harper's, Rolling Stone,* the *New York Times,* and *Saturday Review,* among others, and is currently a contributing editor to *Preservation*. He is the author of seven previous books, including *The Experience of Place* (Alfred A. Knopf, 1990), and in 1994 he was awarded a John Simon Guggenheim Memorial Foundation Fellowship. Mr. Hiss, since 1994, has been a Visiting Scholar at the Taub Urban Research Center of New York University.

Tony Hiss lives in New York City with his wife, the novelist Lois Metzger, and their son, Jacob.

OTHER BOOKS OF PHOTOGRAPHY IN THE SERIES

Alligators, Prehistoric Presence in the American Landscape
Martha A. Strawn, with essays by LeRoy Overstreet, Jane Gibson,
and J. Whitfield Gibbons

Belonging to the West
Eric Paddock

Bravo 20: The Bombing of the American West
Richard Misrach, with Myriam Weisang Misrach

Invisible New York: The Hidden Infrastructure of the City
Stanley Greenberg, with an introductory essay by Thomas H. Garver

Measure of Emptiness: Grain Elevators in the American Landscape
Frank Gohlke, with a concluding essay by John C. Hudson

Nuclear Landscapes
Peter Goin

The Perfect City
Bob Thall, with an essay by Peter Bacon Hales